Do You Like Asshole?

Beautiful Swear Word To Color
For Stress Releasing

Chase C. Demon

Copyright © 2017 by Chase C. Demon

All rights reserved worldwide. No part of this publication may be reproduced or distributed in any form or by any means, mechanical, electronic or stored in a retrieval or database system, without written permission from the copyright holder.

Happy Coloring!

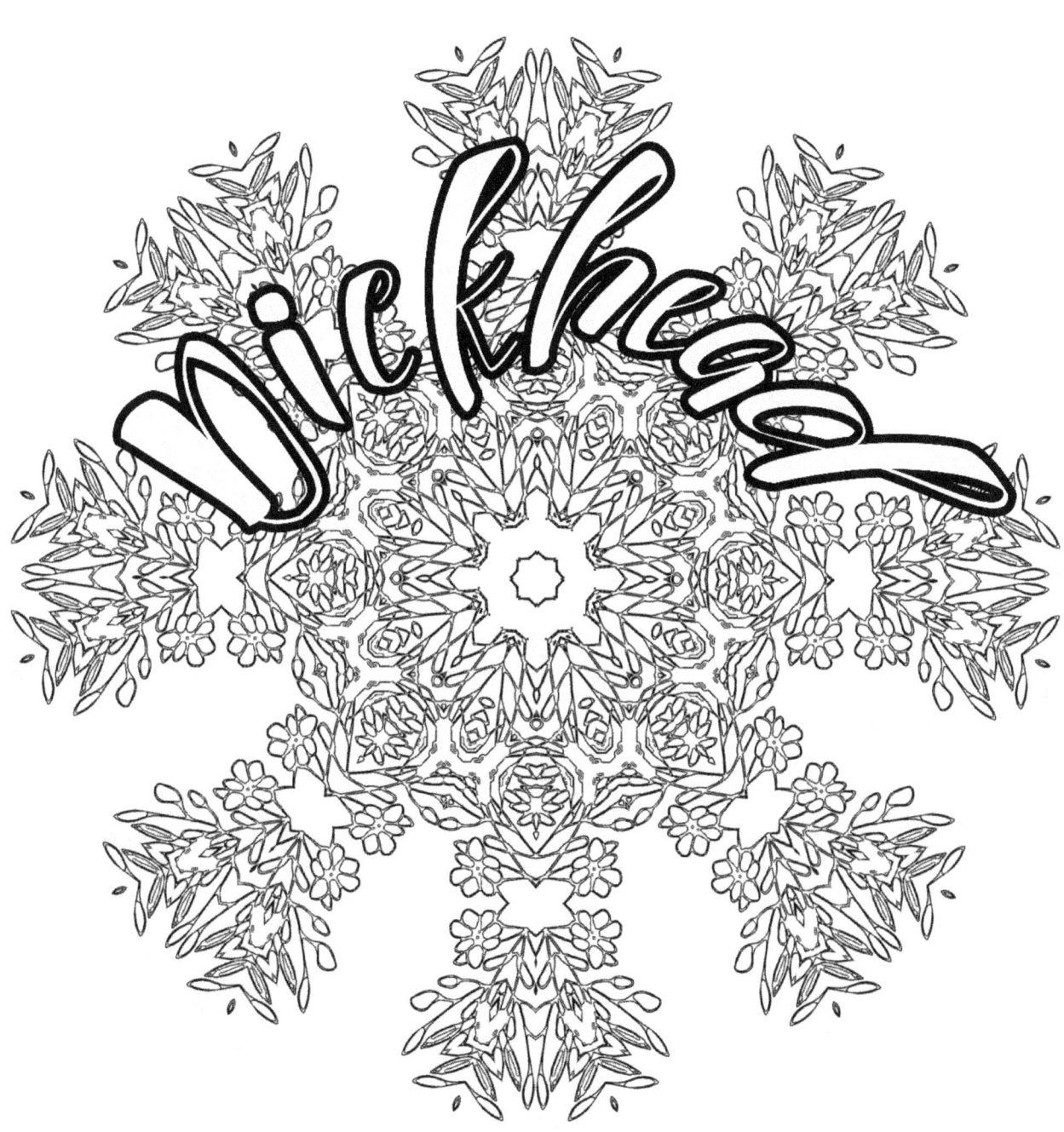

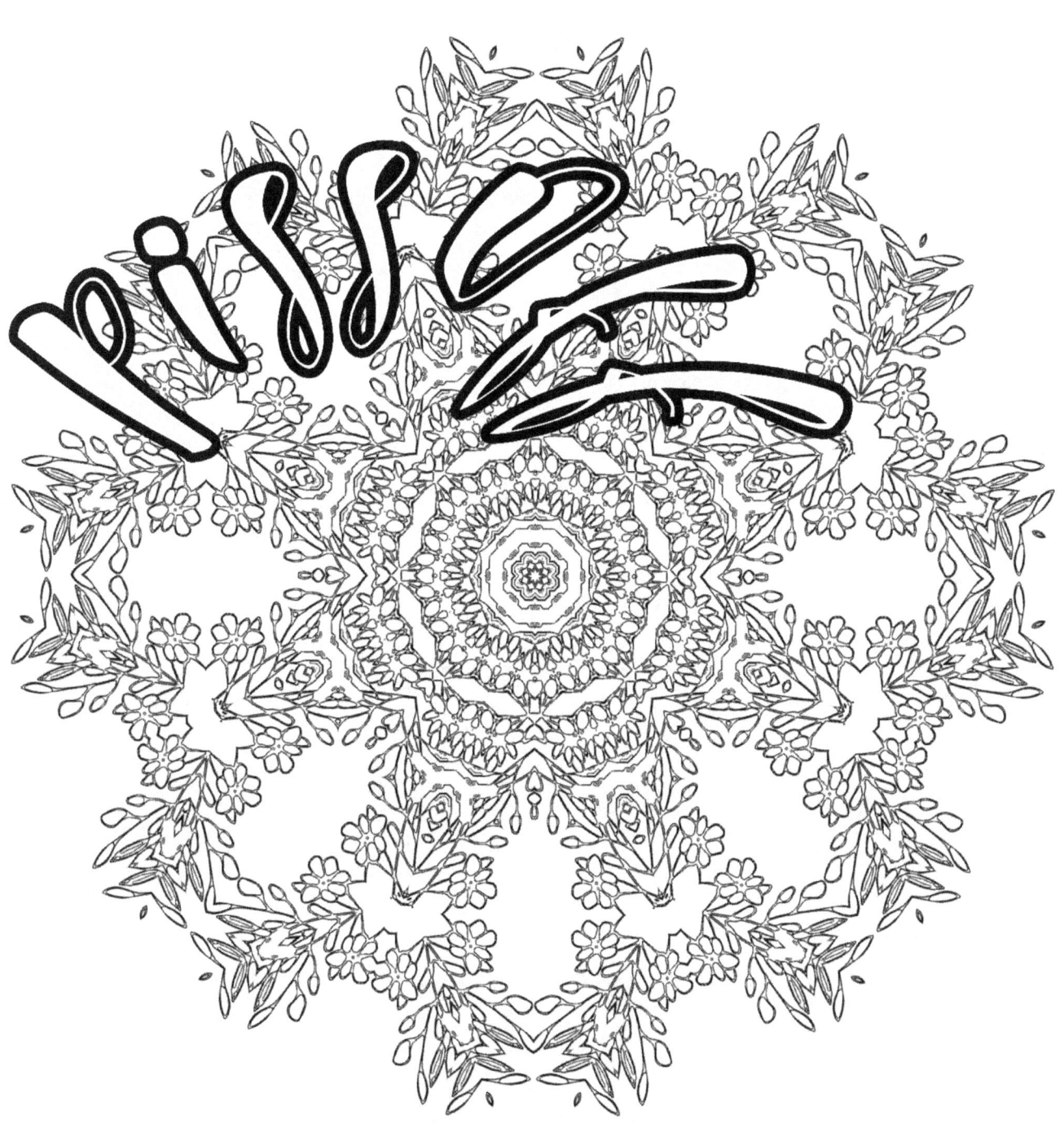

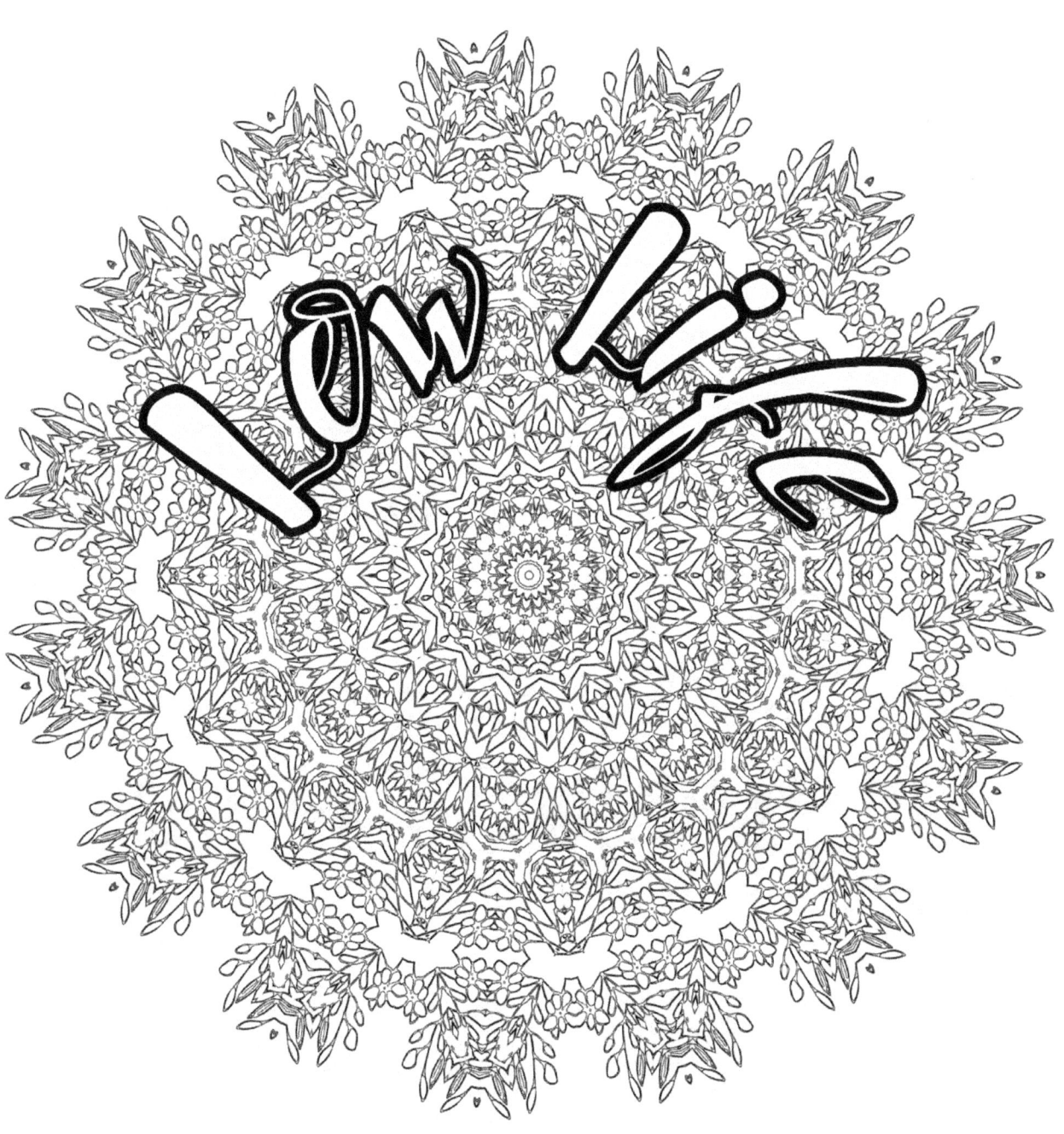

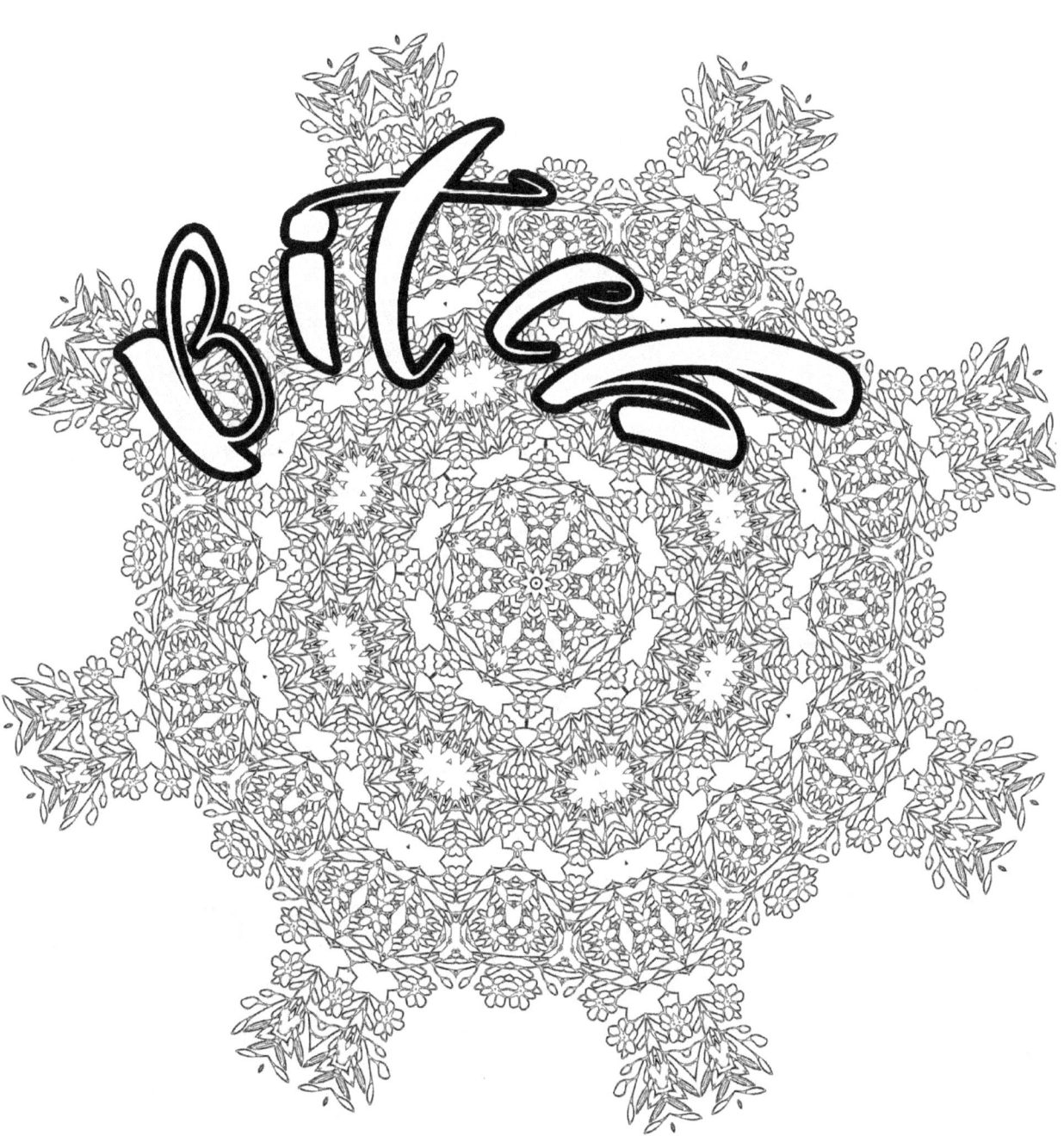

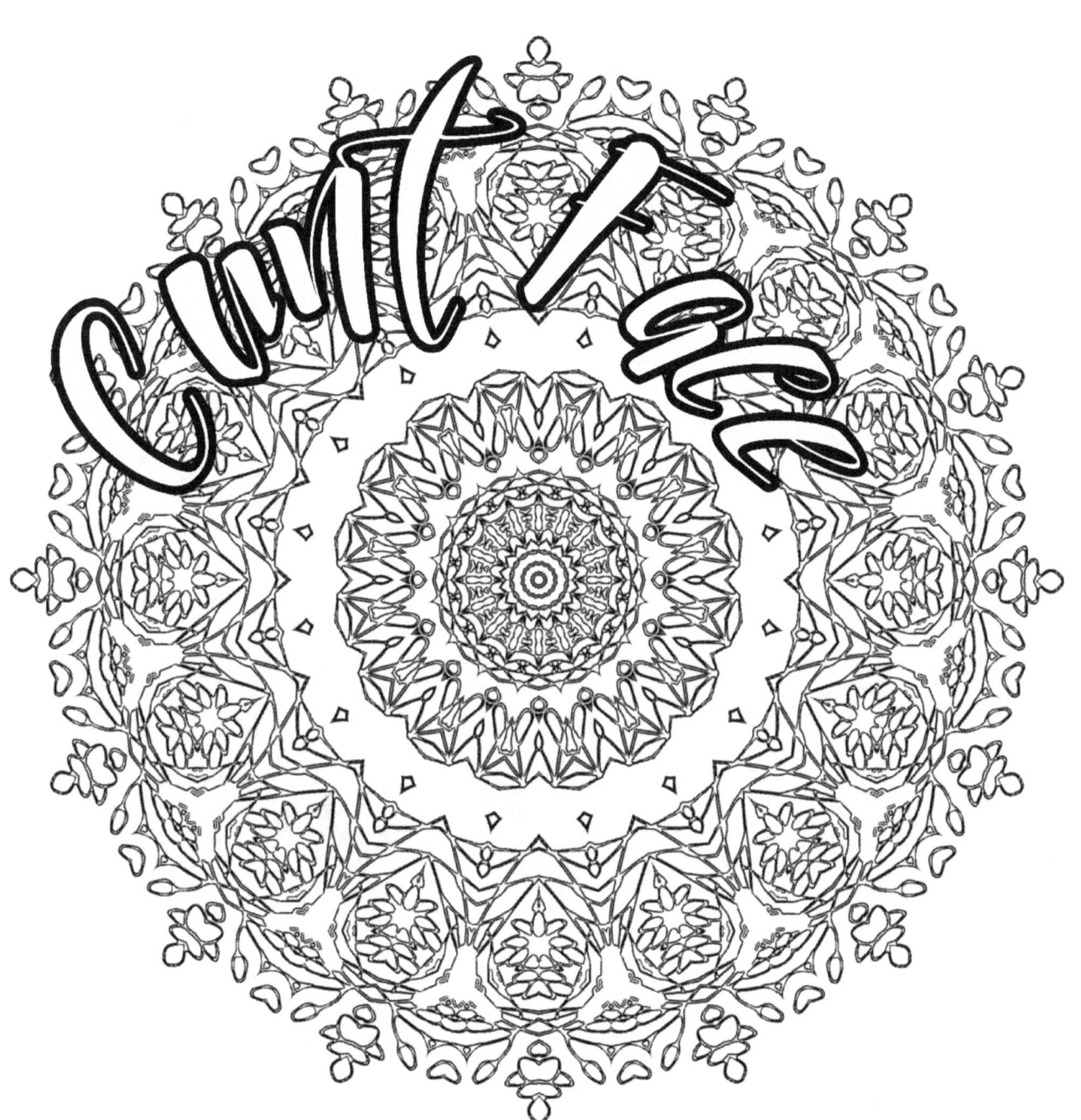

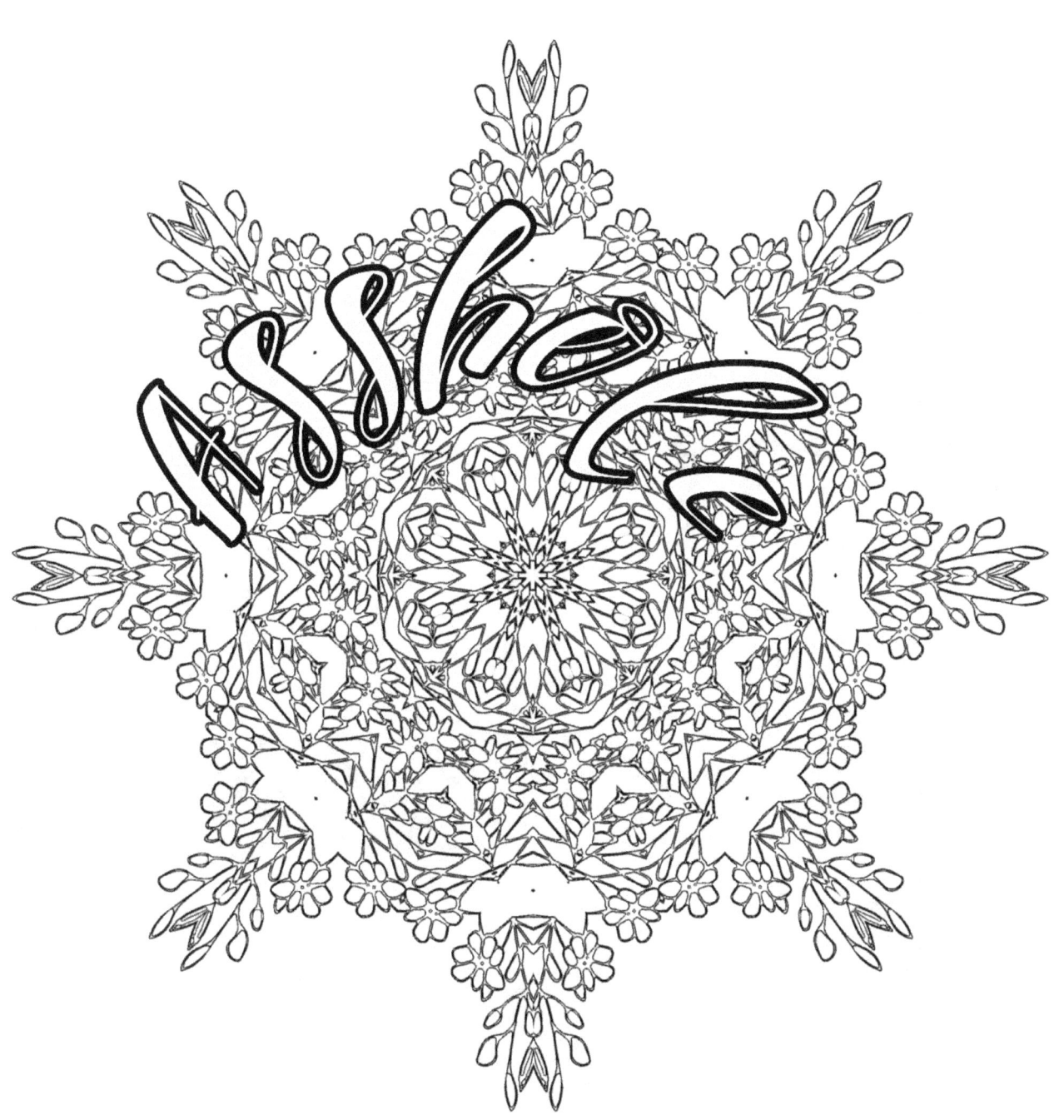

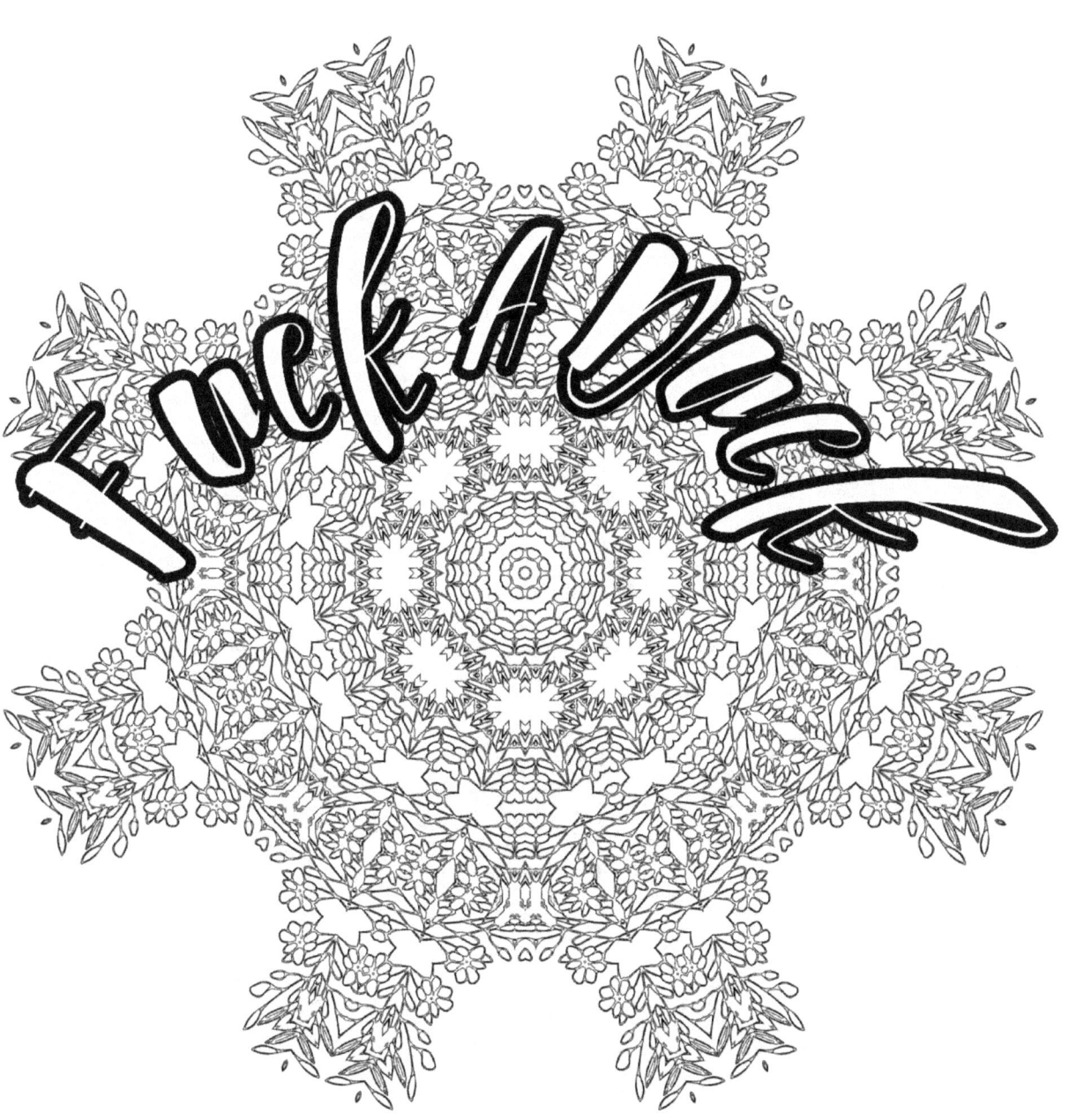

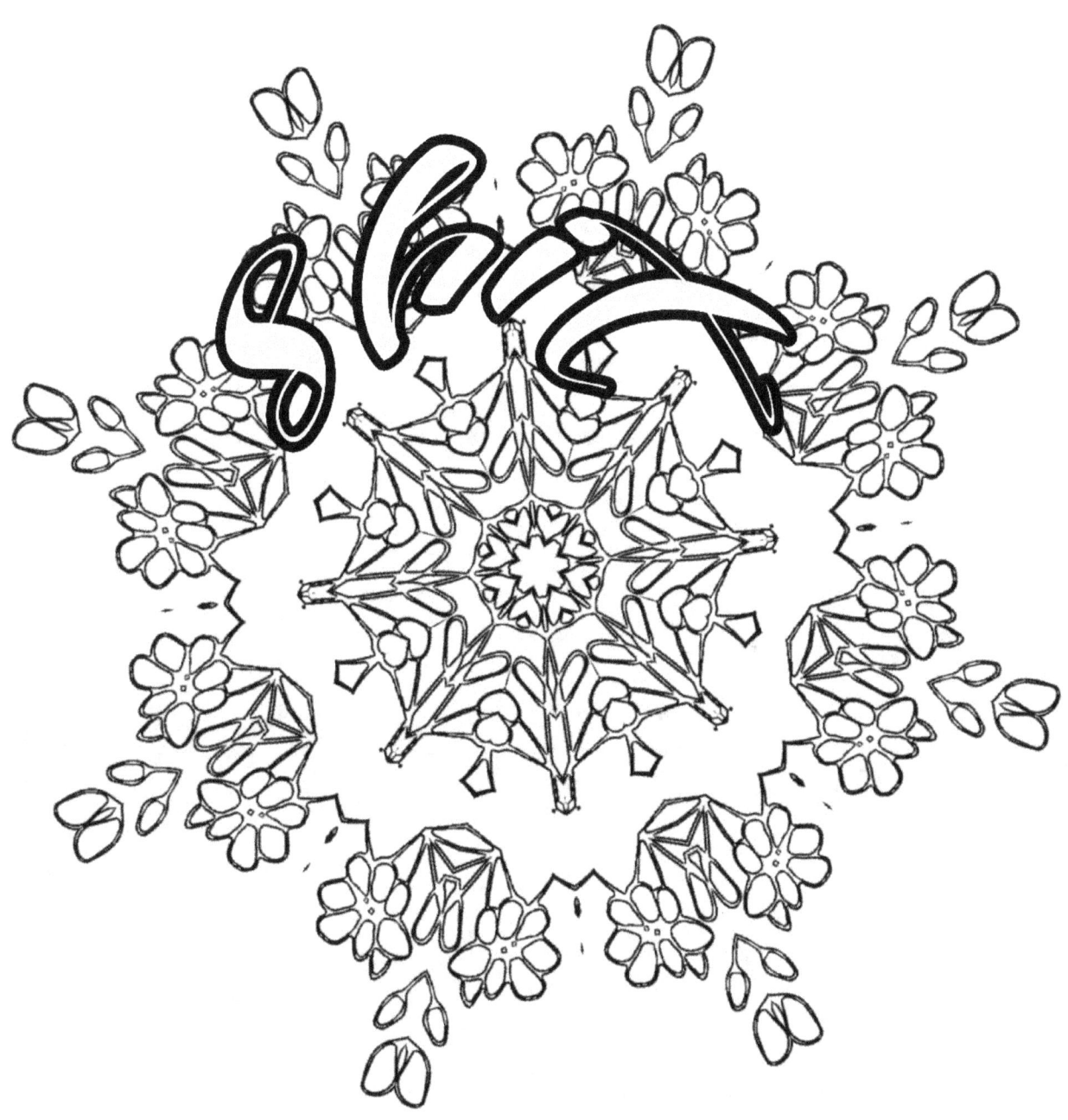

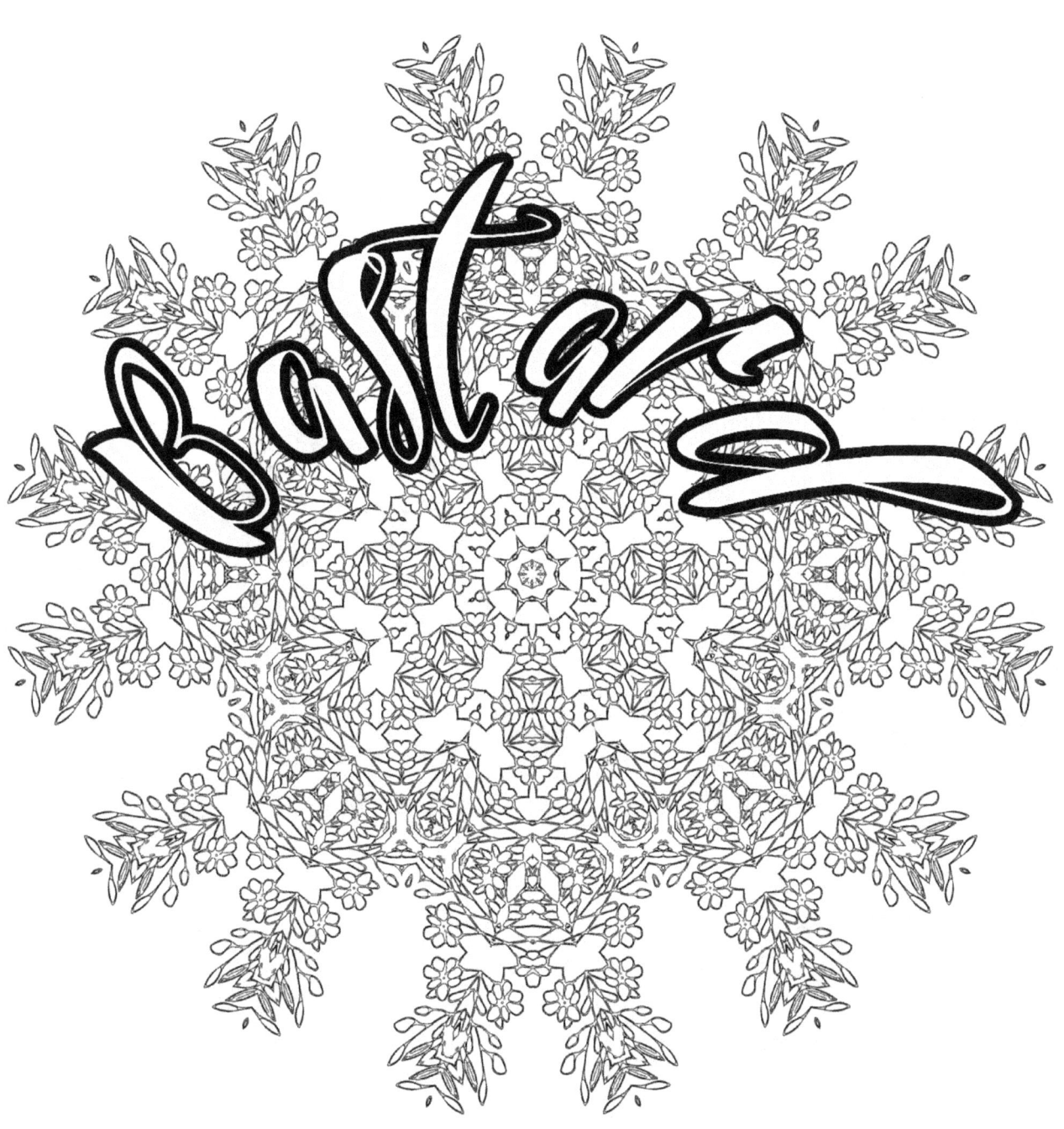

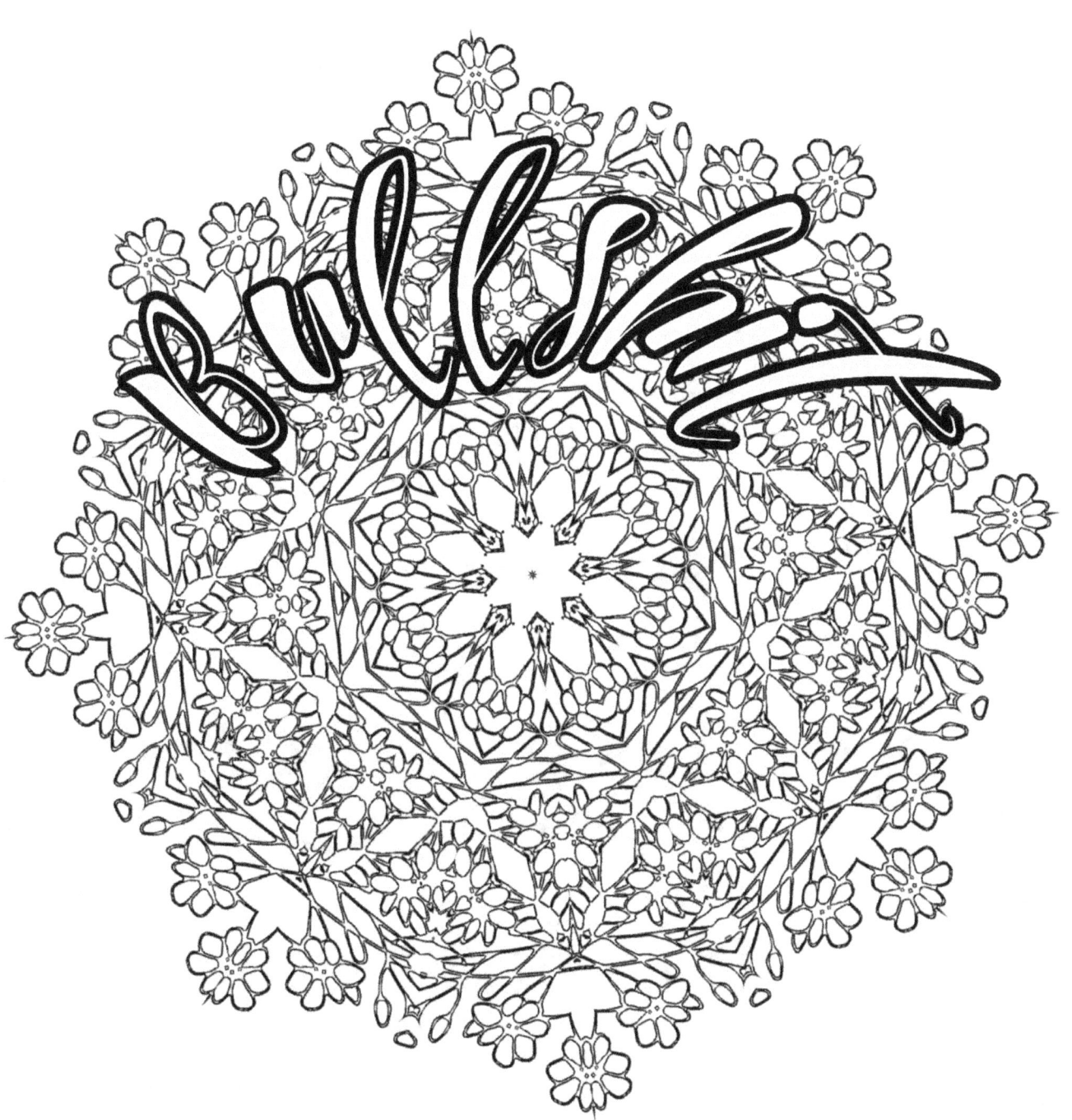

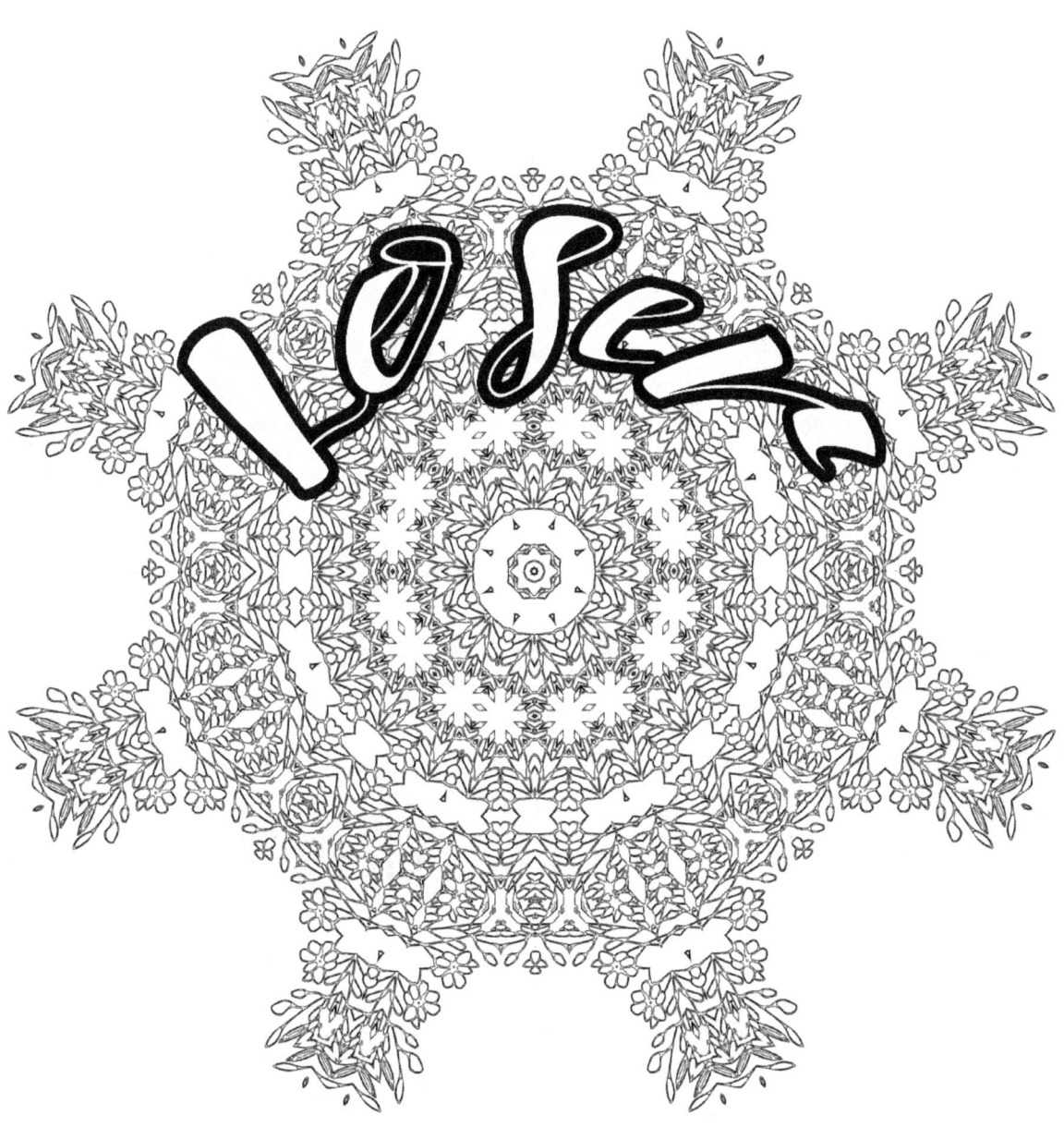

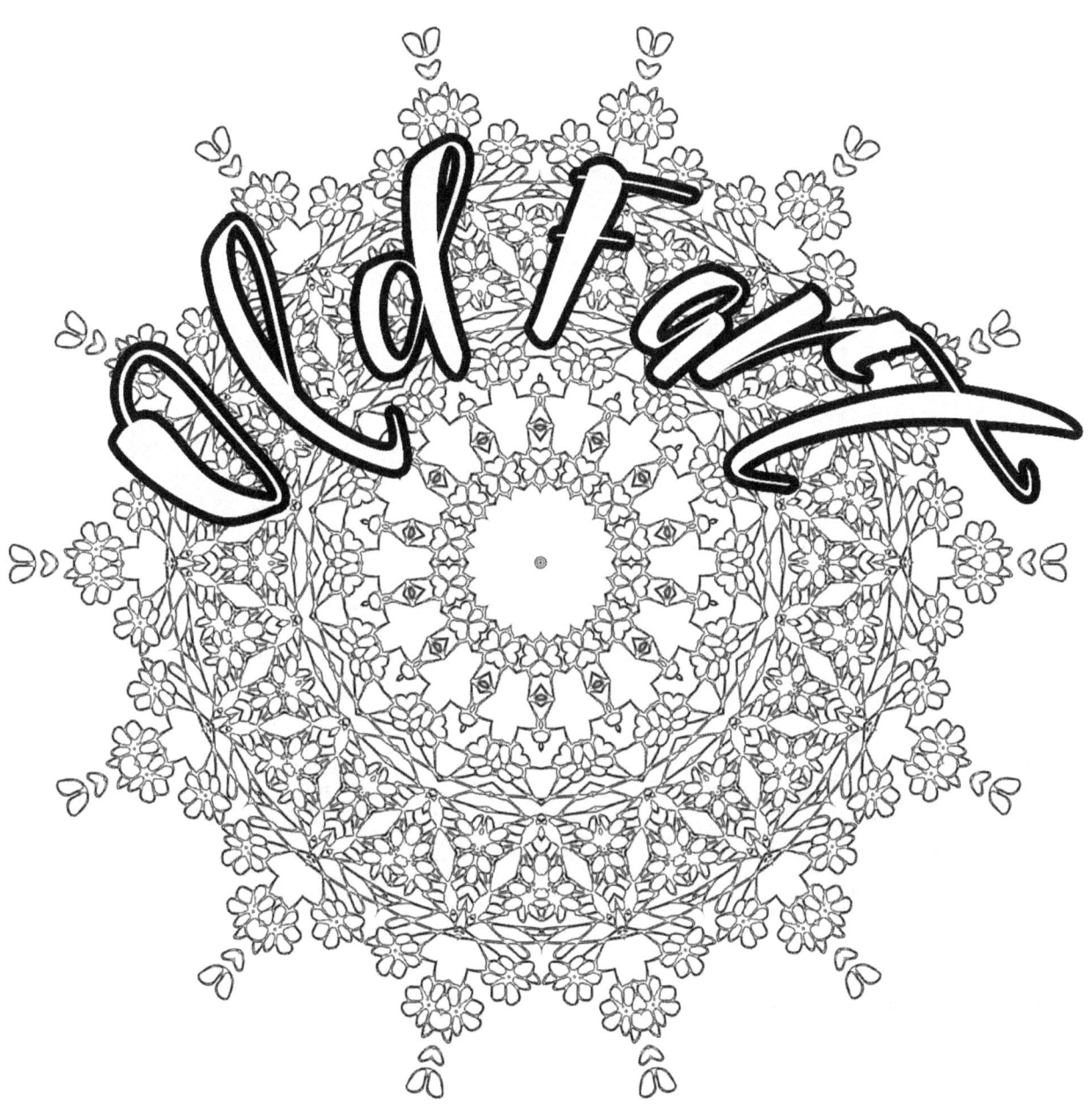

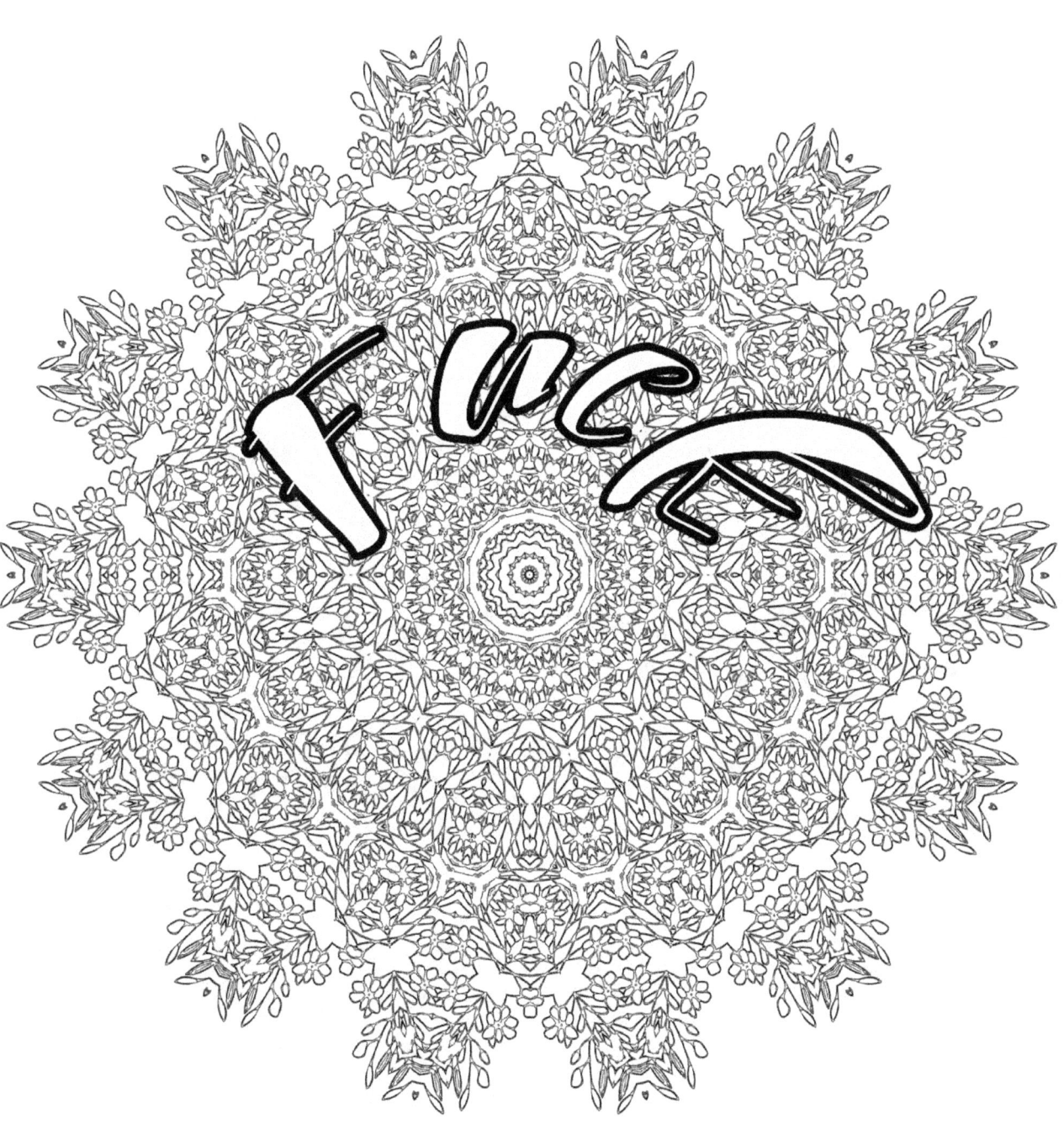

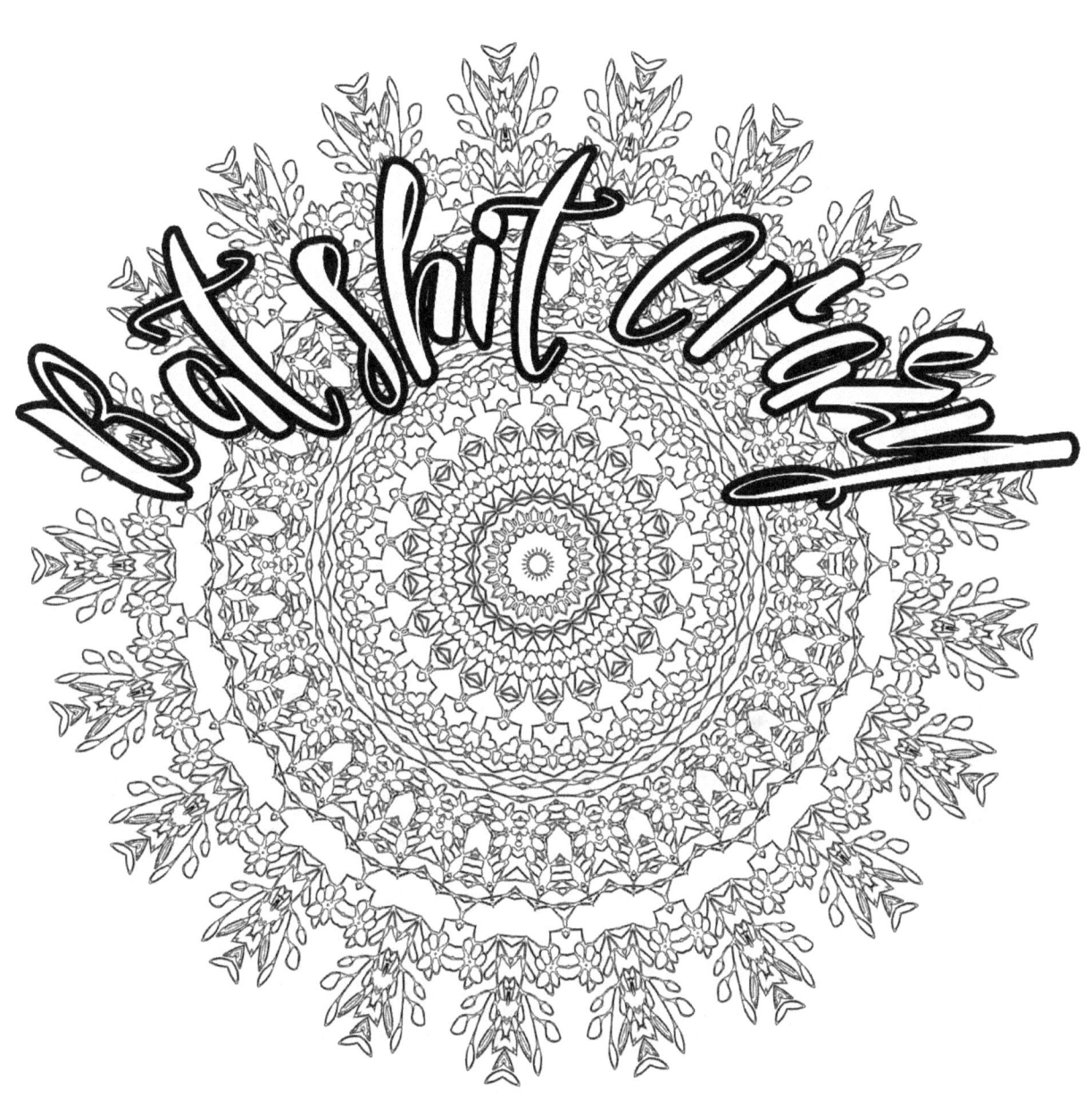

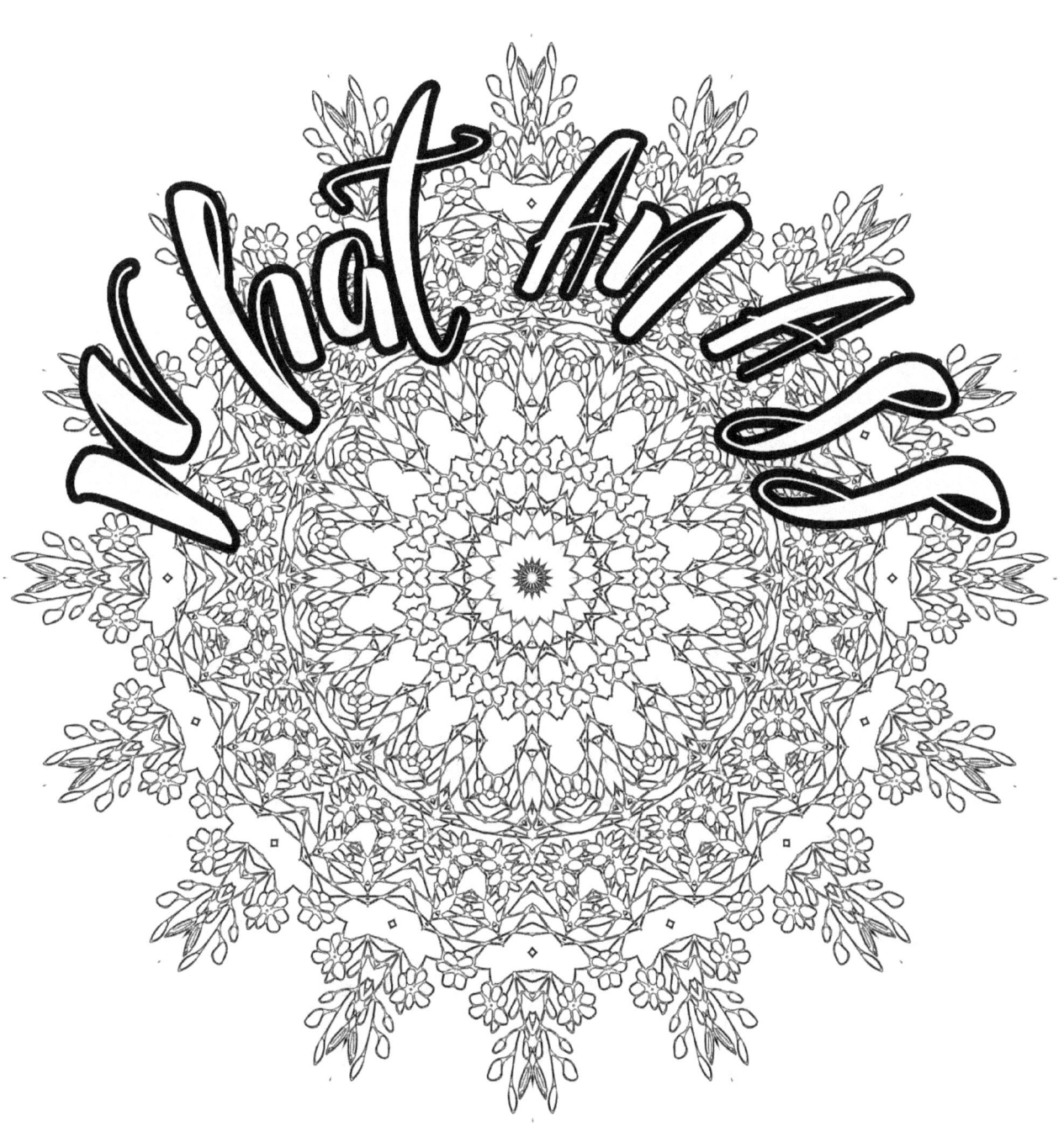

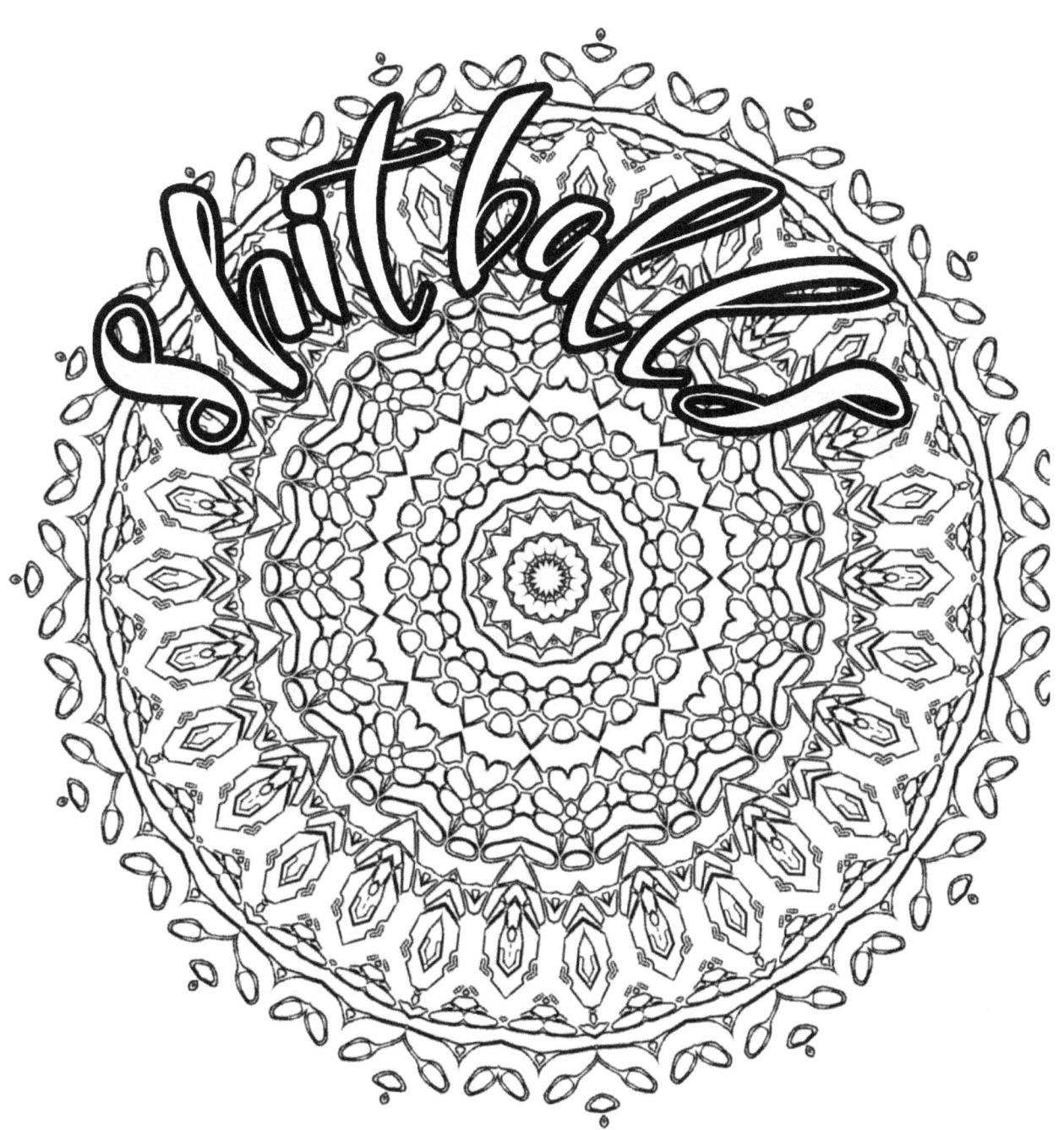

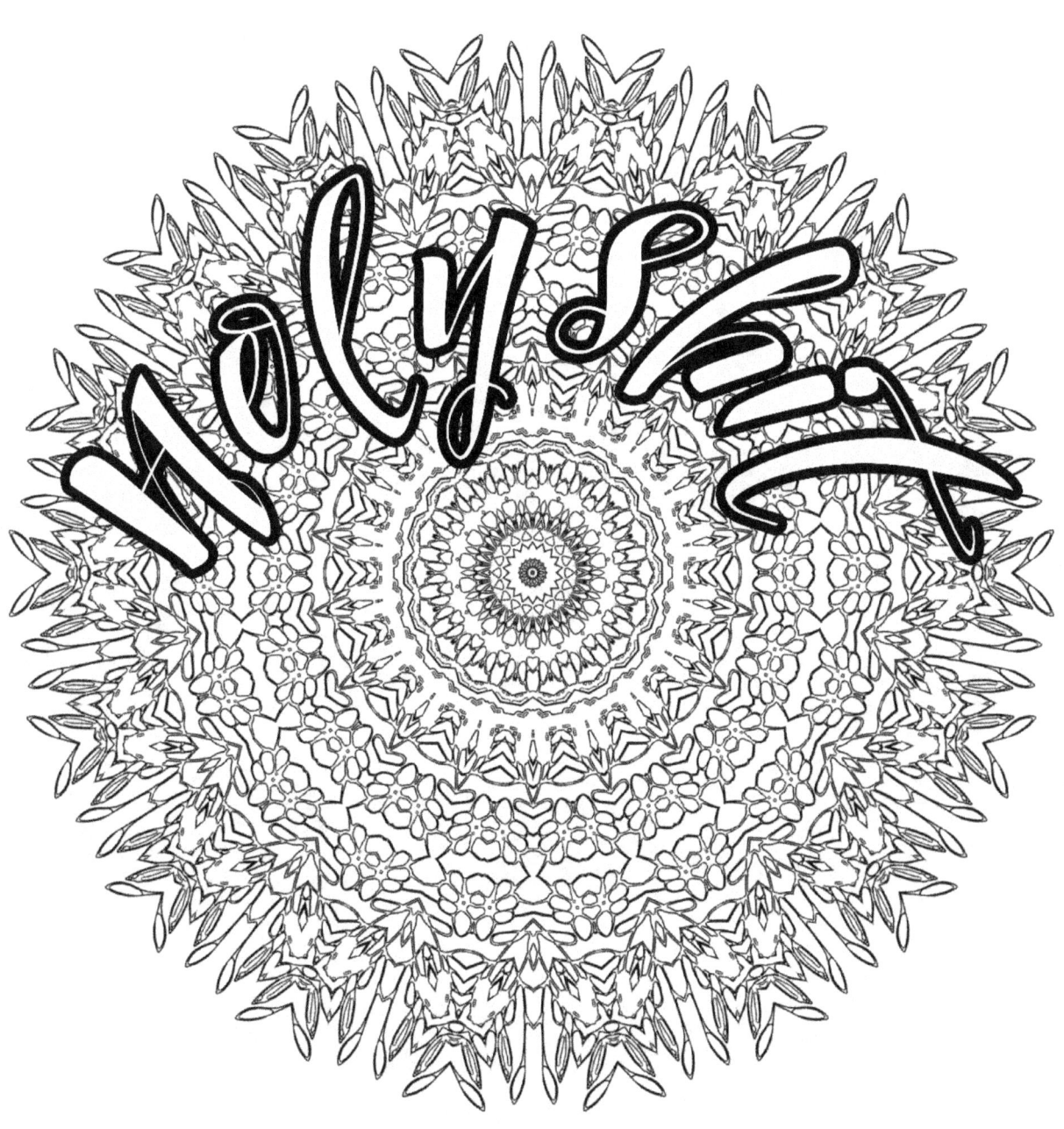

www.ingramcontent.com/pod-product-compliance
Lightning Source LLC
Chambersburg PA
CBHW081130180526
45170CB00008B/3063